Joyfully Jewish

Family & Adult
Coloring Book
for Relaxation
& Meditation

Rae Shagalov

Color Your Soul

M000103017

Copyright 1999-2016 Rae Shagalov
All Rights Reserved.
No part of this book may be reproduced or transmitted
by any form or by any means, electronic or mechanical,
including photocopy, recording, or any information storage
or retrieval system, without prior written consent from the author.

Printed in the United States of America
First Printing, 2016
ISBN: 978-1-937472-03-0 paperback

Holy Sparks Press
www.holysparks.com

Los Angeles

2 Tevet 5776
8th Candle of Hanukkah
Year of Hakhel

Please do not color on Shabbat
or Jewish holy days, as writing
and coloring are prohibited by
Jewish law on those days.

This Publication Is Dedicated To The Rebbe,
Rabbi Menachem M. Schneerson of Lubavitch

whose teachings and inspiration lives in us, and fires us up
to try and reach heights we can't reach on our own,
to prepare the whole world for the imminent arrival of Moshiach.

IN LOVING MEMORY OF

Harav Schneur Zalman Halevi ע"ה
ben Harav Yitzchok Elchonon Halevi הי"ד Shagalov

Reb Dovid Asniel ben Reb Eliyahu ע"ה

Devora Rivka bas Reb Yosef Eliezer ע"ה

Reb Yitzchok Moshe ben Reb Dovid Asniel ע"ה

❧ May Their Souls Merit Eternal Life ☙

AND IN HONOR OF

Mrs. Esther Shaindel bas Fraidel Chedva שתחי' Shagalov
and Our Dear Children and Grandchildren שיחיו
May You Always Be Joyfully Jewish!

DEDICATED BY

Rabbi & Mrs. Yosef Yitzchok and Gittel Rachel שיחיו Shagalov

To dedicate future editions in
honor or memory of your
loved ones, contact us at:
info@holysparks.com

❧ Introduction ❧

I love to learn the secrets of the Torah, about the spiritual energies of our soul, and about all of the ways we can transform this world, little-by-little, into a dwelling place for *G-d. Over the last 25 years, with the help of G-d, I've written 3,000 pages of calligraphy Artnotes, illustrated with graphics suitable for coloring, that record the Jewish wisdom of hundreds of Torah leaders for our special time, the threshold of the Messianic Era of peace.

"Joyfully Jewish" is the first book in the "Color Your Soul" series of family and adult coloring books that integrate the relaxing, meditative art of coloring with deep Chassidic secrets of Judaism. It includes fun designs to color with unique Jewish quotes from traditional sources and contemporary Jewish masters written in beautiful calligraphy. It is an uplifting introduction to Jewish spirituality.

Coloring is a very relaxing, peaceful, meditative activity. As you color in the pages, contemplate the Artnotes thoughts on them and try to internalize them. If you're doing this as a family activity, discuss the ideas while you color them in together. Afterwards, hang up these beautiful family treasures around your home to set a Joyfully Jewish tone.

I would love to see your colorful creations, so let's connect!
Feel free to email me with questions, suggestions & pictures of your coloring at: info@holysparks.com

Sign up to receive free art, coloring pages and Rae Shagalov's Soul Tips newsletter! Go to: www.holysparks.com

Let's Connect!
Facebook.com/soultips
Pinterest.com/holysparks
Twitter.com/holysparks
Youtube.com/holysparksbooks
Instagram.com/holysparks

*Out of reverence for G-d, the Jewish people do not write out the whole name of G-d.

❧ How To Use This Book ❧

Coloring can help you relax into a peaceful and contemplative mood, so for best results, turn off the phone, computer and any other stressful distractions, if you can. Place a piece of cardboard or a few sheets of paper under the page if you are using pens so the ink won't bleed through.

Gather your colored pencils or pens. Flip through the book and choose a page that sparks your interest. Intuitively choose your colors and don't fret if you make a "mistake" or color outside the lines. Just relax and continue, letting your mind wander and enjoy the colors. Being in this relaxed state will improve your life and outlook, but you can also use it to go higher into holiness.

How? You could listen to a Torah class while coloring, or you could meditate on the greatness of G-d. When you are in this relaxed state, it is a very good time to think about and speak to G-d. It's a wonderful place to be in to think about your life, your family and friends and how you can improve yourself and your relationships. It's a lovely interlude for creatively thinking about a new *mitzvah you would like to do, or imagining how you could do a mitzvah more beautifully than ever before. It's a special time to dream about what the world will be like when **Moshiach comes, G-d willing, very, very soon to usher in the great era of peace that we all wait and wish for. When you do this, you elevate the act of coloring by serving G-d with it.

May G-d keep you from all manner of harm and distress and bless the works of your hands with success, in good health, with great joy, and abundant livelihood – and may you always be Joyfully Jewish!

Rae Shagalov

*Mitzvahs are Divine Commandments, channels of G-dly light, that connect us to G-d.

**Moshiach is the Jewish world leader, a descendent of King David, who will rebuild the Temple in Jerusalem and gather the Jewish people out of exile, back to Israel. Moshiach will lead us into Geulah, a world of complete peace and abundance, without war or suffering. The coming of Moshiach will complete G-d's purpose in creation - for us to make a dwelling place for G-d in this world, by transforming and elevating the material things of this world into spirituality, through learning Torah, and doing mitzvahs and acts of goodness and kindness.

בס"ד

These Hebrew letters appear at the top of each coloring page.
This is an abbreviation for the Aramaic phrase "B'Sayata Di'shamaya,"
which means, "With the Help of Heaven."
This reminds us that everything comes from G-d.

בס"ד

Joyfully Jewish

Put your photo in the middle ©1990-2015 Rae Shagalov WWW.HOLYSPARKS.COM

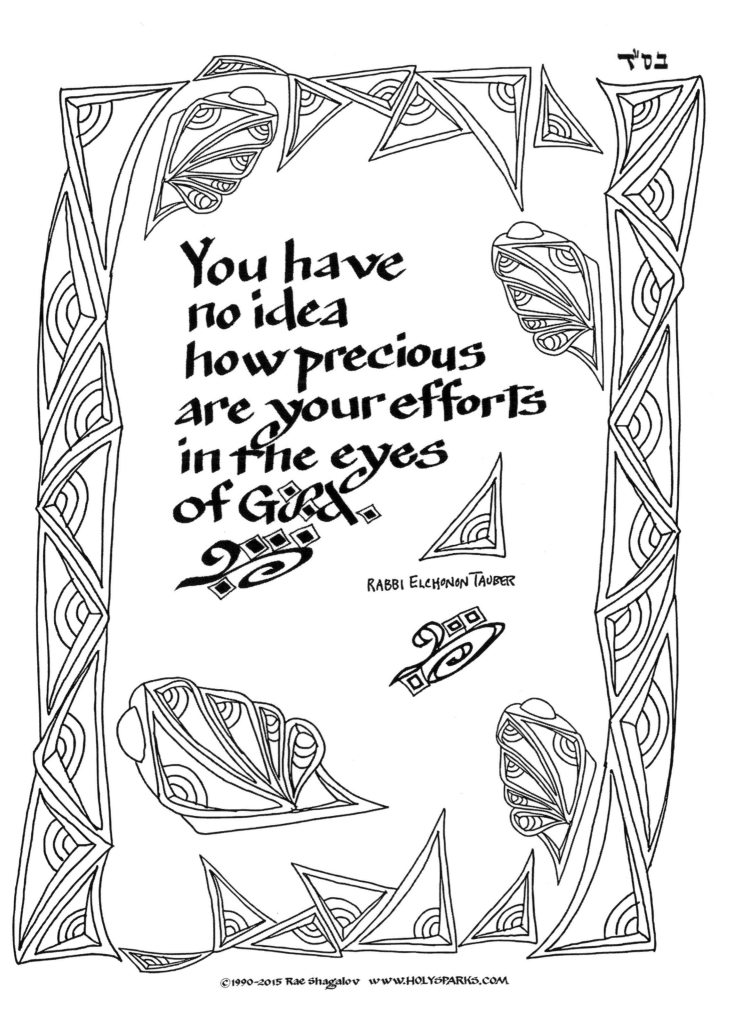

בס״ד

You have no idea how precious are your efforts in the eyes of G‑d.

RABBI ELCHONON TAUBER

©1990-2015 Rae Shagalov WWW.HOLYSPARKS.COM

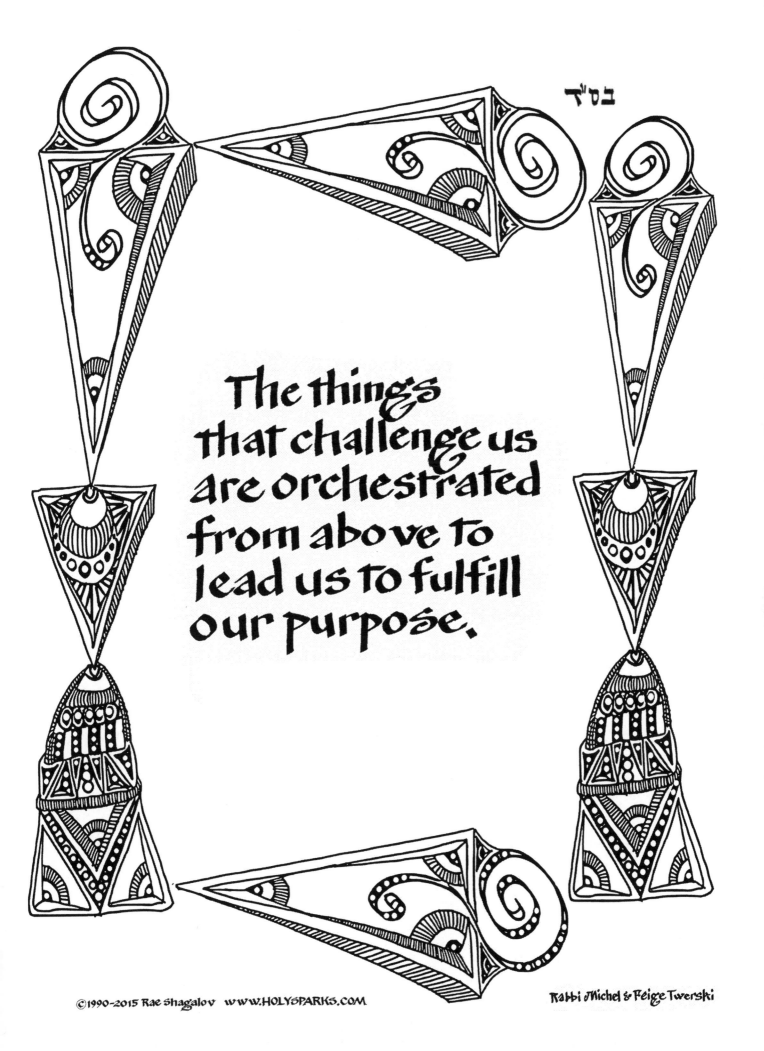

בס"ד

The things that challenge us are orchestrated from above to lead us to fulfill our purpose.

©1990-2015 Rae Shagalov www.HOLYSPARKS.COM

Rabbi Michel & Feige Twerski

בס"ד

What is our purpose?

To do?

Good

To make a
dwelling place
for G-d;
to make a
deeper vessel
for holiness.

©1990-2015 Rae Shagalov www.HOLYSPARKS.com

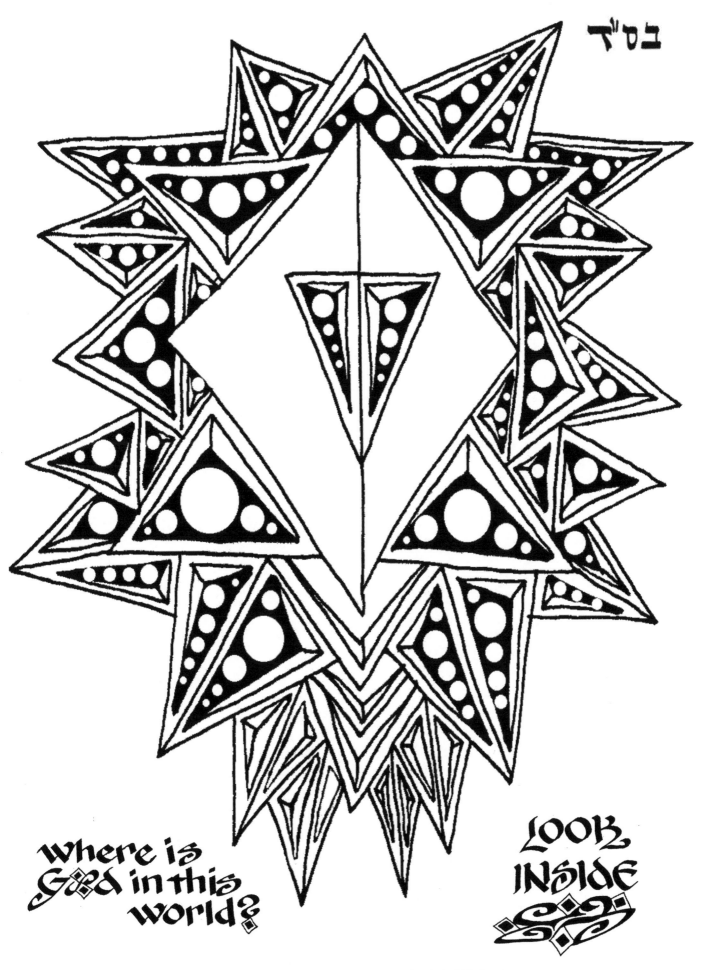

בס"ד

where is G‑d in this world?

LOOK INSIDE

©1990-2015 Rae Shagalov www.HOLYSPARKS.COM

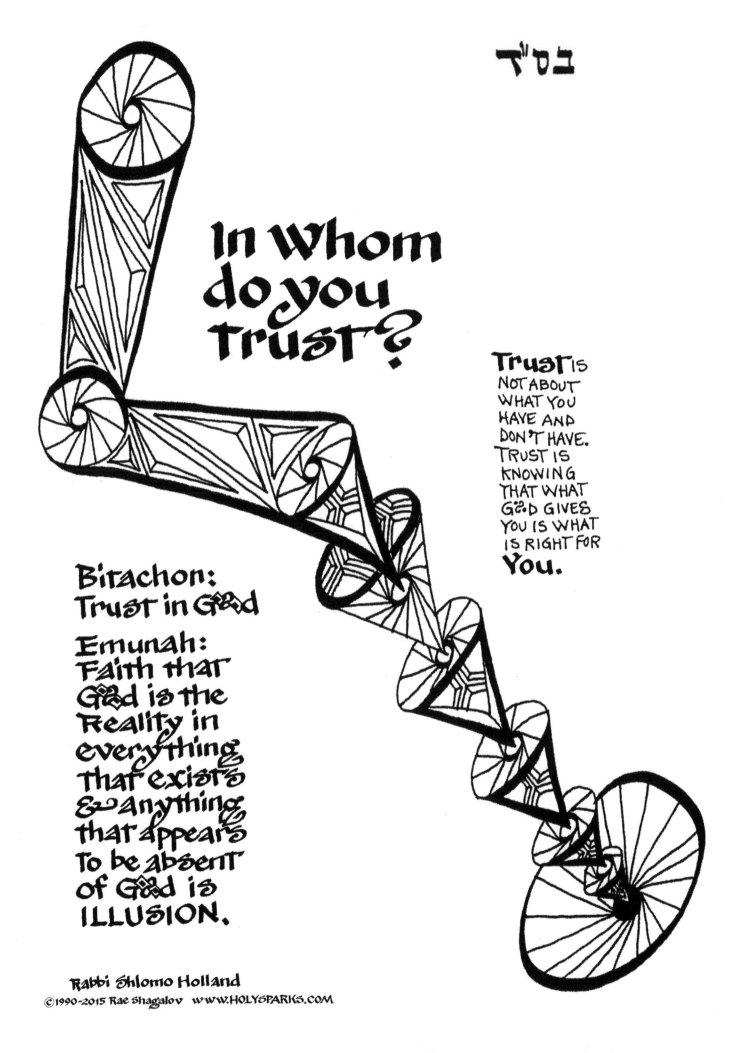

בס"ד

In whom do you trust?

Trust is not about what you have and don't have. Trust is knowing that what G‑d gives you is what is right for You.

Bitachon: Trust in G‑d

Emunah: Faith that G‑d is the Reality in everything that exists & anything that appears to be absent of G‑d is ILLUSION.

Rabbi Shlomo Holland

©1990-2015 Rae Shagalov www.HOLYSPARKS.COM

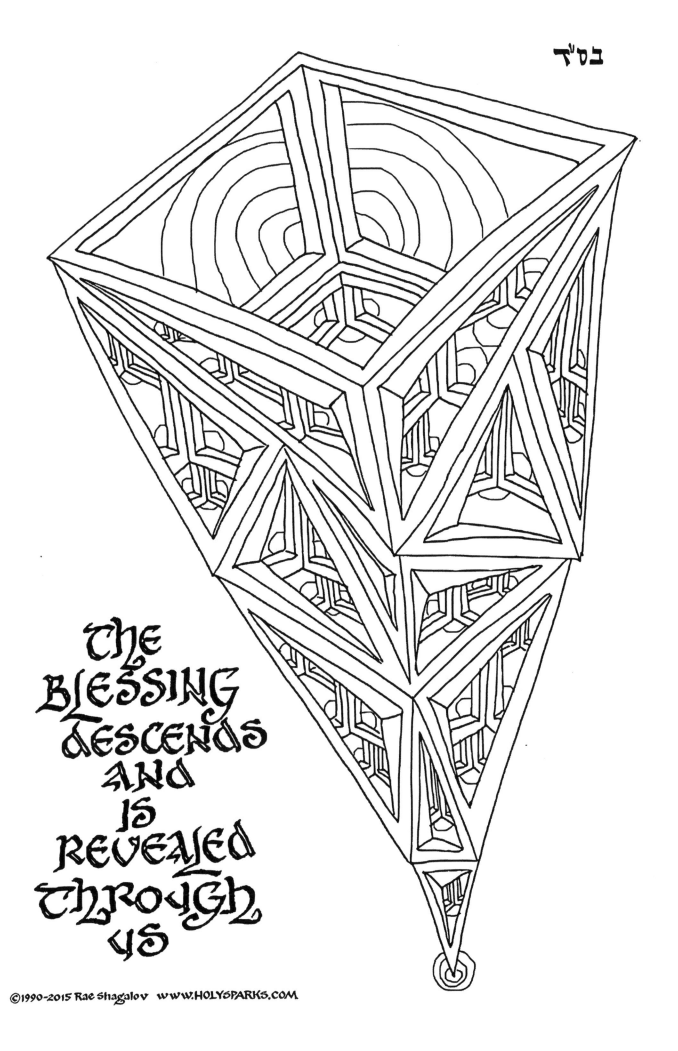

בס״ד

THE
BLESSING
descends
and
is
revealed
through
us

©1990-2015 Rae Shagalov WWW.HOLYSPARKS.COM

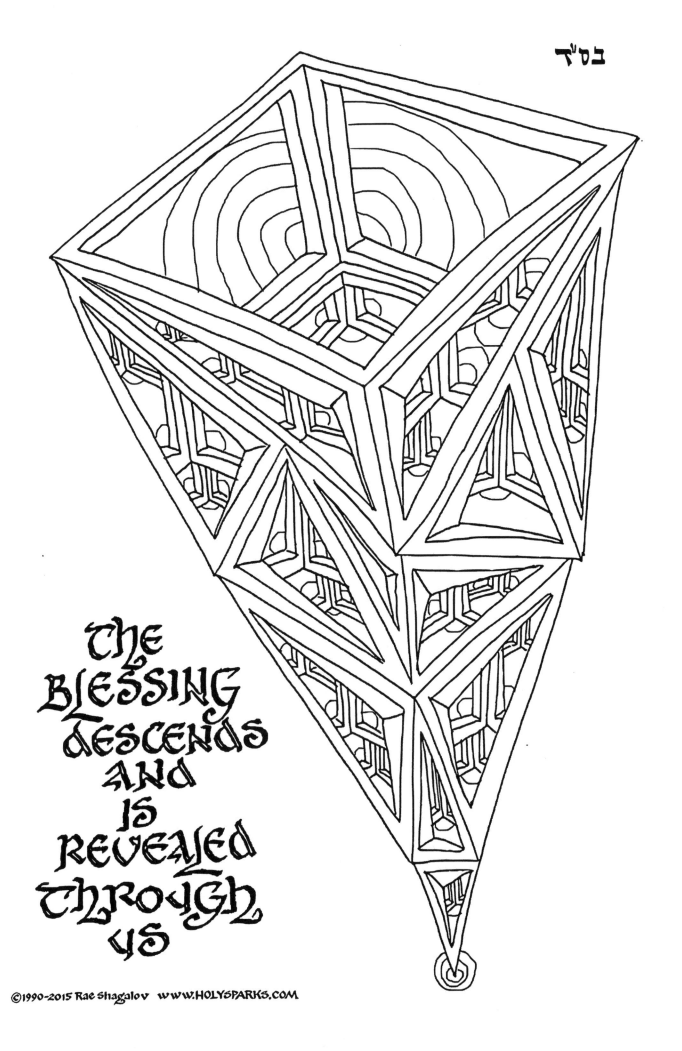

ב״ס״ד

The
BLESSING
descends
and
is
revealed
through
us

©1990-2015 Rae Shagalov www.HOLYSPARKS.com

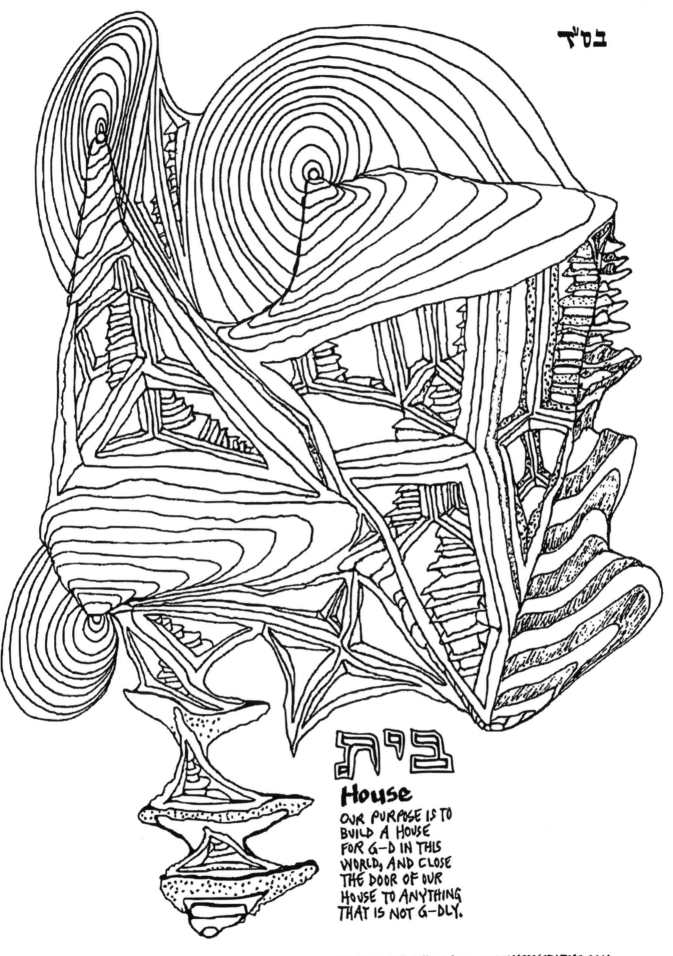

בס״ד

בַּיִת

House

OUR PURPOSE IS TO
BUILD A HOUSE
FOR G-D IN THIS
WORLD, AND CLOSE
THE DOOR OF OUR
HOUSE TO ANYTHING
THAT IS NOT G-DLY.

©1990-2015 Rae Shagalov WWW.HOLYSPARKS.COM

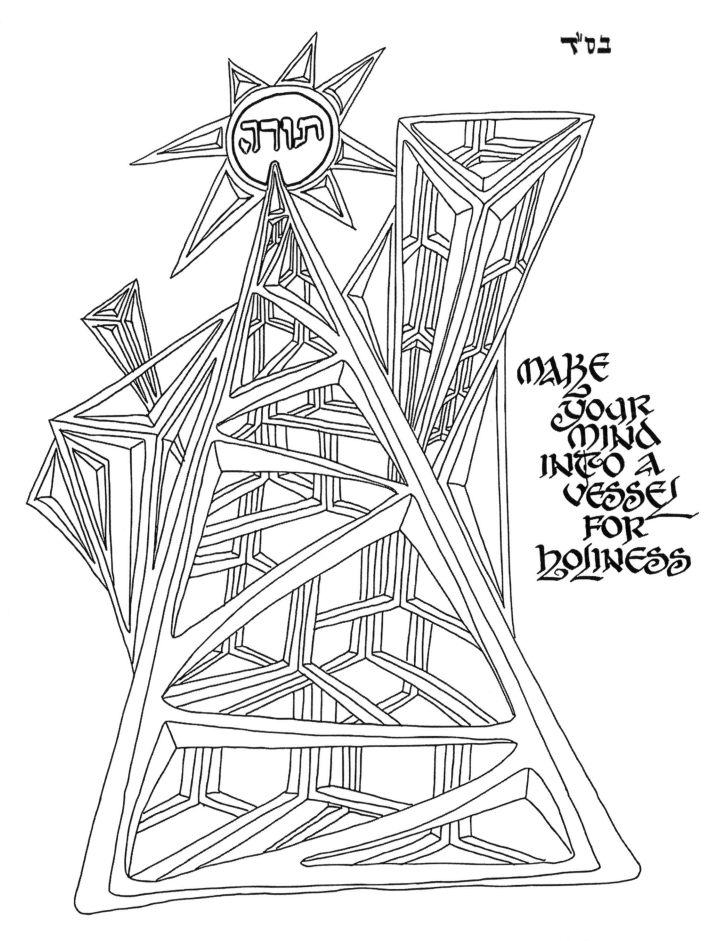

בס״ד

תורה

MAKE
YOUR
MIND
INTO A
VESSEL
FOR
HOLINESS

©1990-2015 Rae Shagalov www.HOLYSPARKS.COM

drifting on the moving walkway of HaShem

בס"ד

WISH YOU WERE HERE!

RETURNING to SELF

Holy Sparks
WWW.HOLYSPARKS.COM
©1990-2015 Rae Shagalov

בס"ד

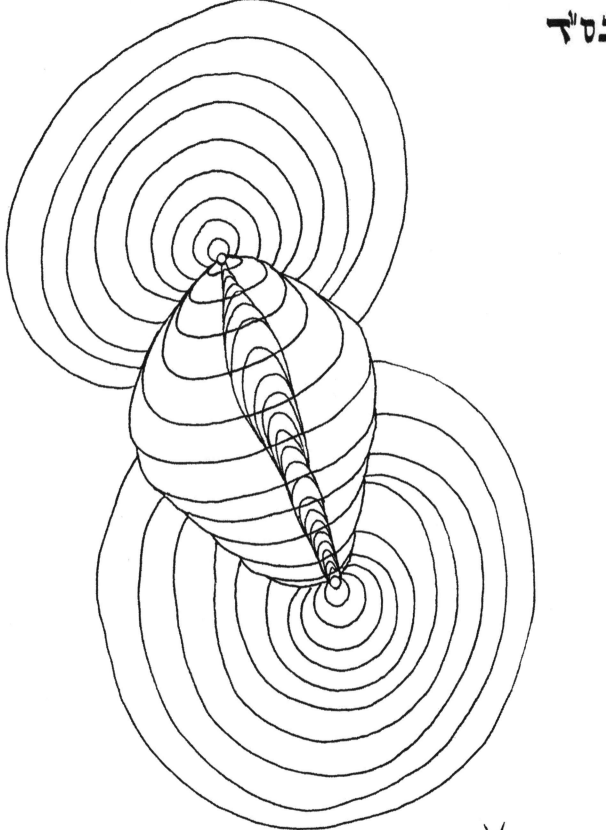

The Infinite Light radiates into the source of all souls

Holy Sparks
www.HOLYSPARKS.COM
©1990-2015 Rae Shagalov

CHASSIDUT • MALCHON ALTE • R.TURKOFF DERECH MITZVOTECHA , TZEMACH TZEDDIK

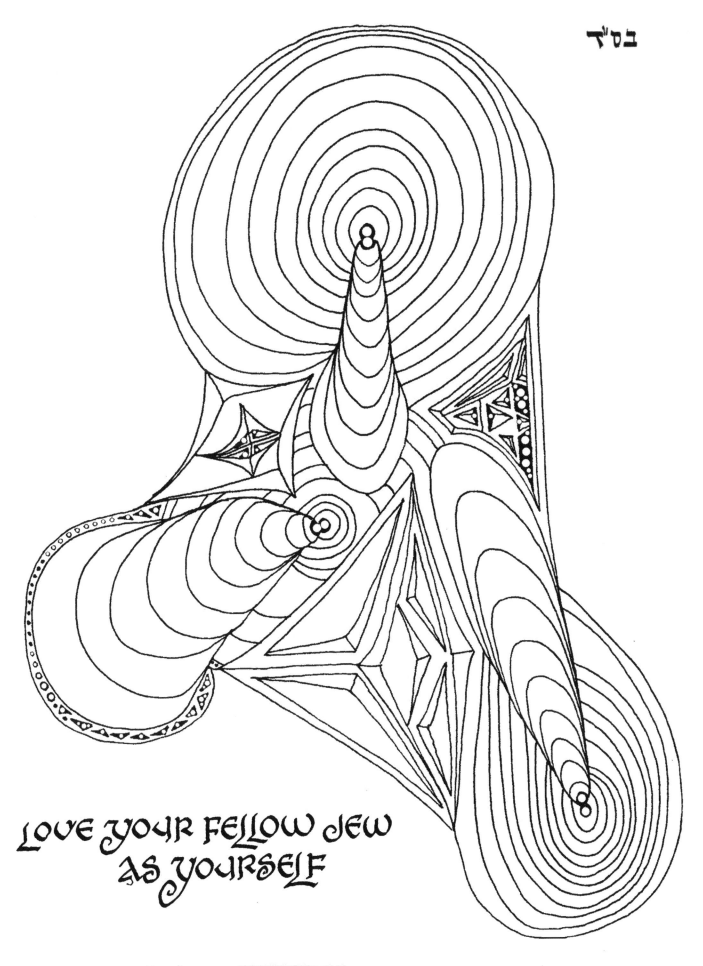

בס"ד

LOVE YOUR FELLOW JEW AS YOURSELF

©1990-2015 Rae Shagalov WWW.HOLYSPARKS.COM

בס"ד

LET THE UMBRELLA OF SELF-LOVE COVER ALSO YOUR NEIGHBOR

WHEN YOU OVERLOOK THE SHORTCOMINGS OF YOUR NEIGHBOR, G-d WILL OVERLOOK YOUR FAULTS

FOCUS IN & MEDITATE ON THE POINT OF CONNECTION WITH YOUR NEIGHBOR

BLESS US ALL AS ONE

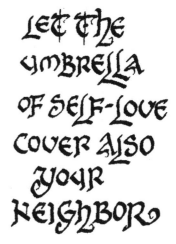

Holy Sparks

WWW.HOLYSPARKS.COM
©1990-2015 Rae Shagalov

CHASSIDUT • MALCHON ALTE • R. TURKOFF DERECH MITZVOTECHA, TZEMACH TZEDDIK

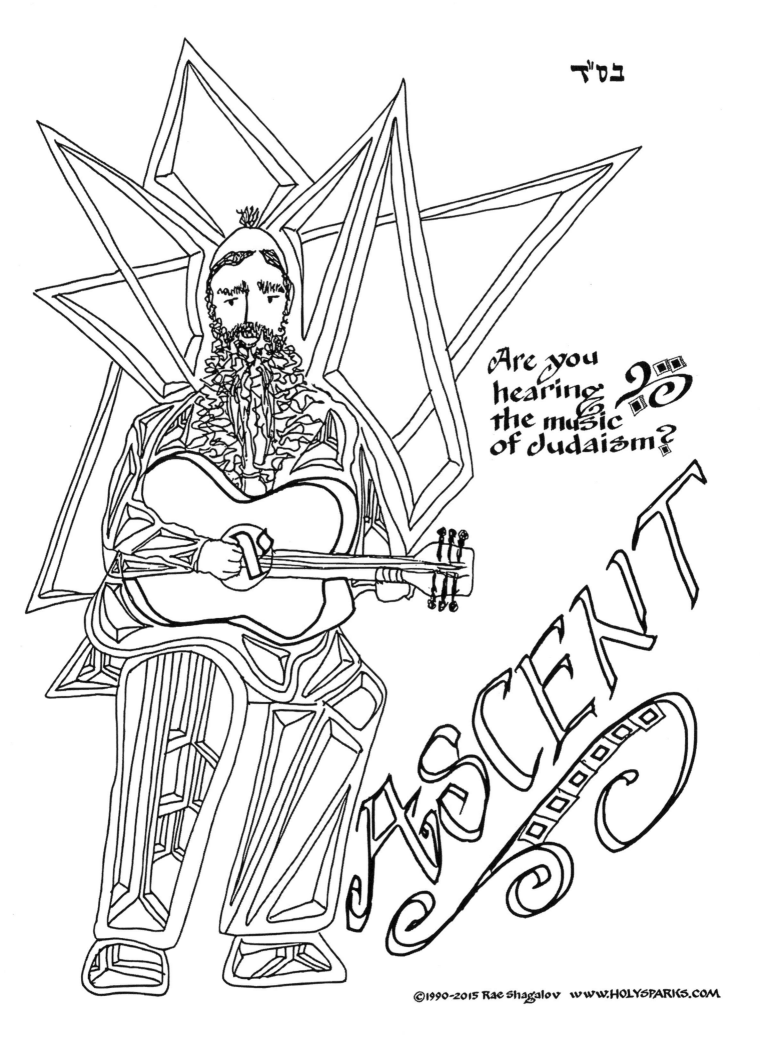

FROM THE
deep places
I call you
G‑d

בס"ד

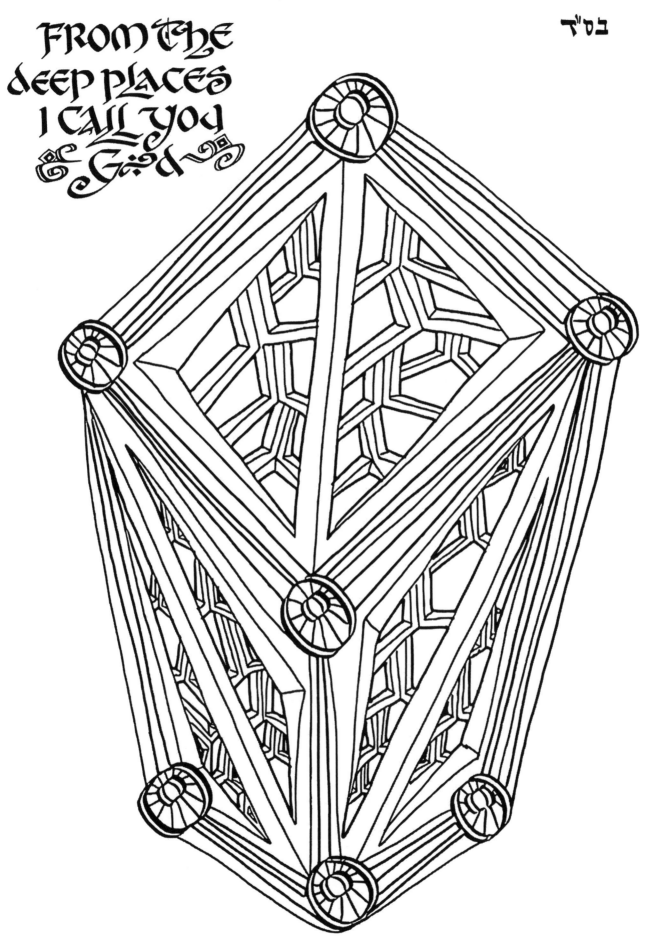

Tehillim - Psalms - Chapter 130

©1990-2015 Rae Shagalov www.HOLYSPARKS.COM

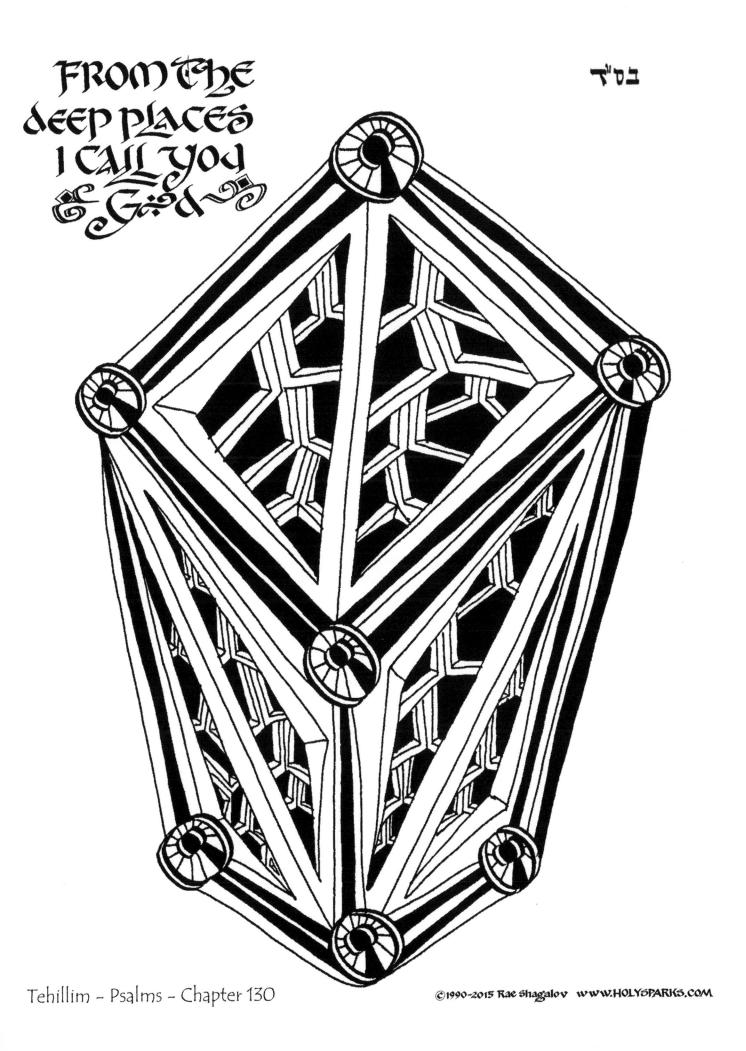

FROM THE
deep places
I call you
& G‑d

בס״ד

Tehillim – Psalms – Chapter 130

©1990–2015 Rae Shagalov www.HOLYSPARKS.com

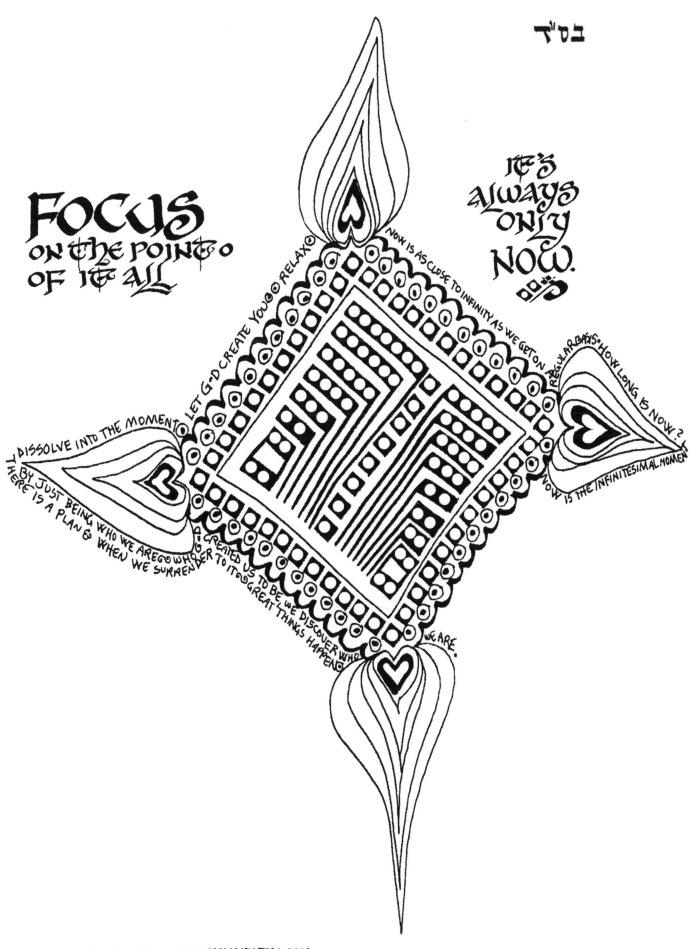

FOCUS ON THE POINT OF IT ALL

IT'S ALWAYS ONLY NOW.

בס"ד

©1990-2015 Rae Shagalov WWW.HOLYSPARKS.COM

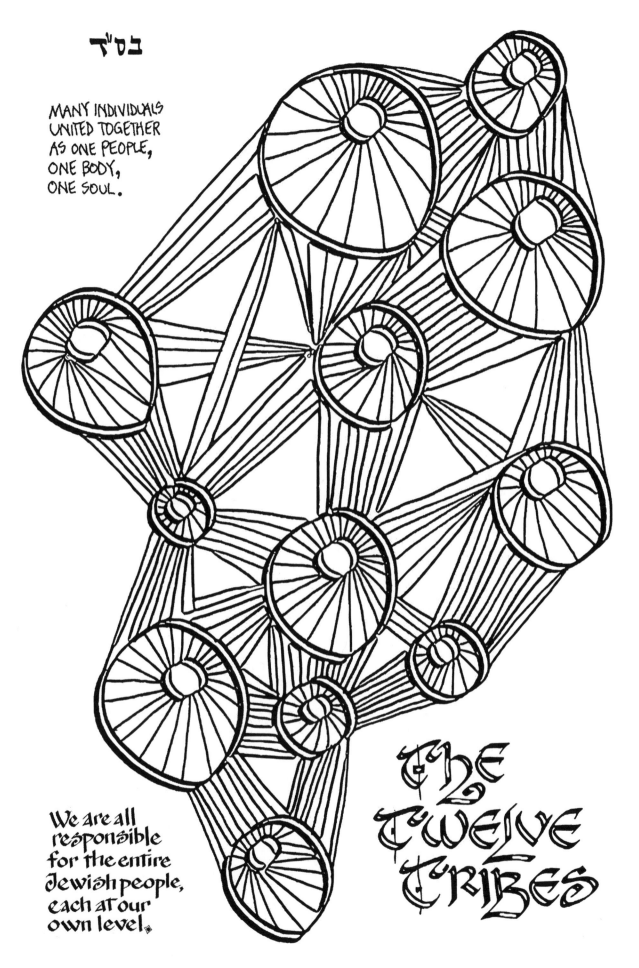

בס"ד

MANY INDIVIDUALS
UNITED TOGETHER
AS ONE PEOPLE,
ONE BODY,
ONE SOUL.

We are all
responsible
for the entire
Jewish people,
each at our
own level.

THE
TWELVE
TRIBES

Rabbi Nachum Sauer ©1990-2015 Rae Shagalov www.HOLYSPARKS.COM

בס״ד

MANY INDIVIDUALS
UNITED TOGETHER
AS ONE PEOPLE,
ONE BODY,
ONE SOUL.

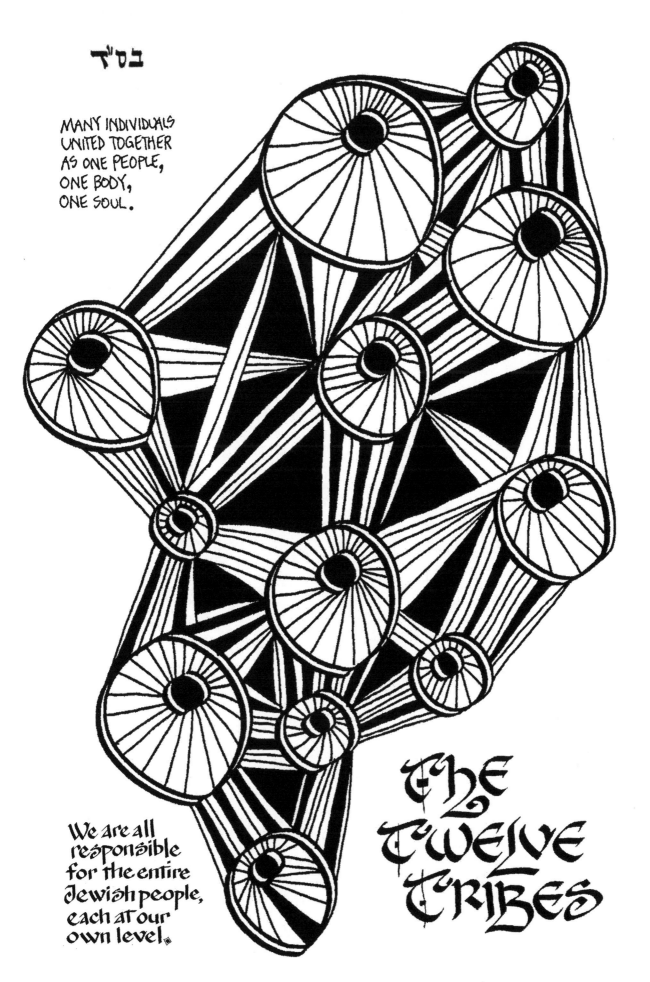

We are all
responsible
for the entire
Jewish people,
each at our
own level.

THE TWELVE TRIBES

Rabbi Nachum Sauer

©1990-2015 Rae Shagalov WWW.HOLYSPARKS.COM

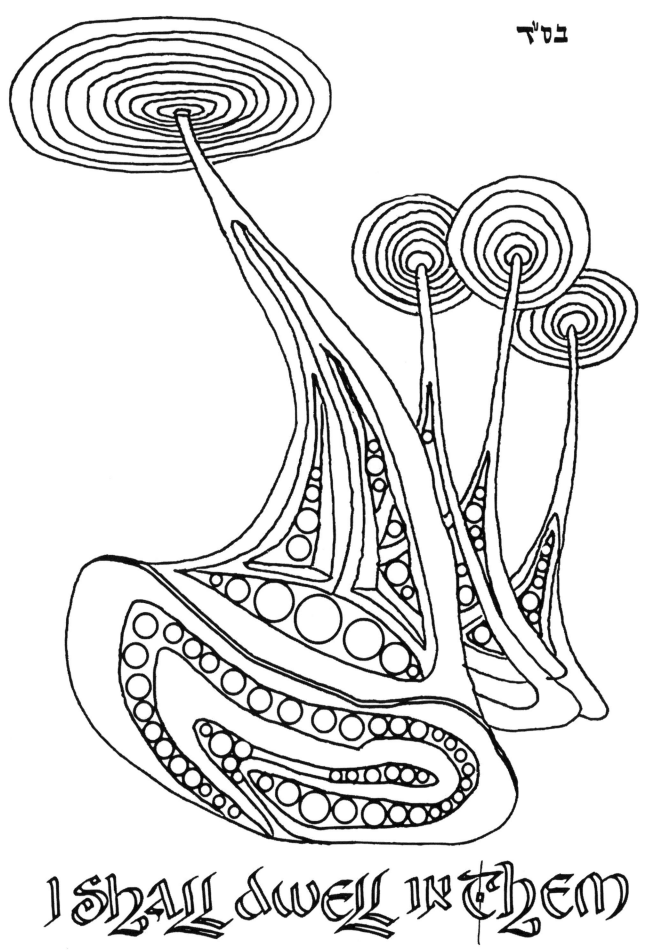

בס"ד

I SHALL DWELL IN THEM

©1990-2015 Rae Shagalov www.HOLYSPARKS.COM

Exodus 25:8

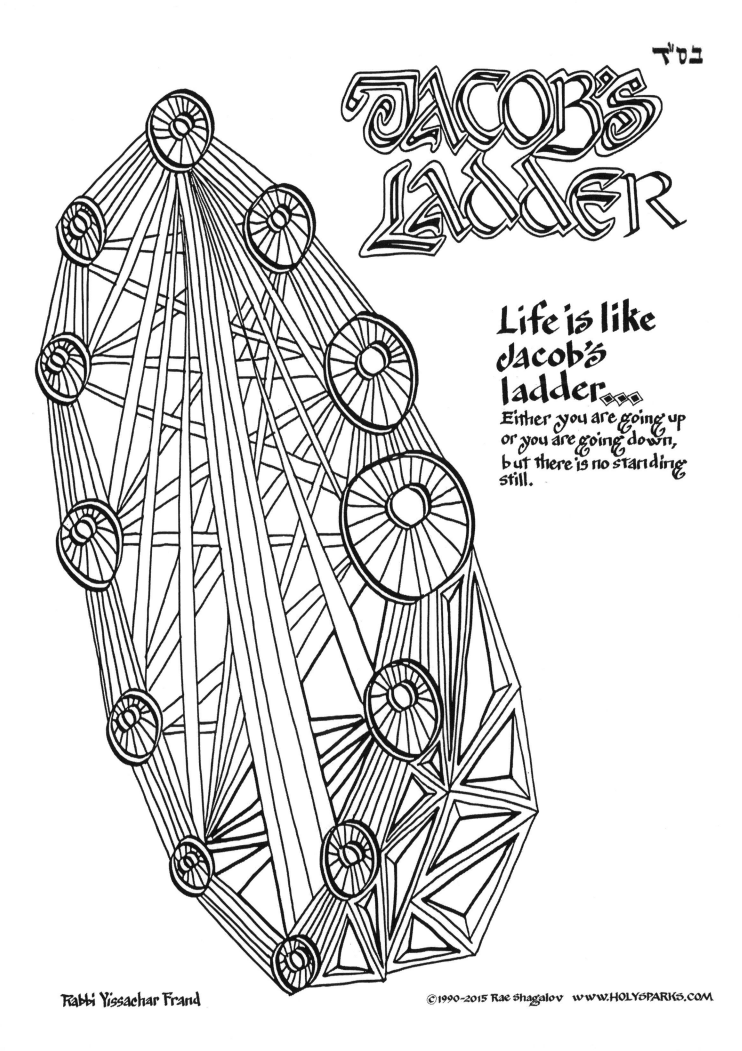

ב"ס"ד

JACOB'S LADDER

Life is like Jacob's ladder...
Either you are going up or you are going down, but there is no standing still.

Rabbi Yissachar Frand

©1990-2015 Rae Shagalov www.HOLYSPARKS.COM

בס"ד

IF YOU ARE ATTRACTED TO EVIL
IT IS YOUR JOB TO OVERCOME IT

If you are attracted to holiness,
It is your job to maximize it

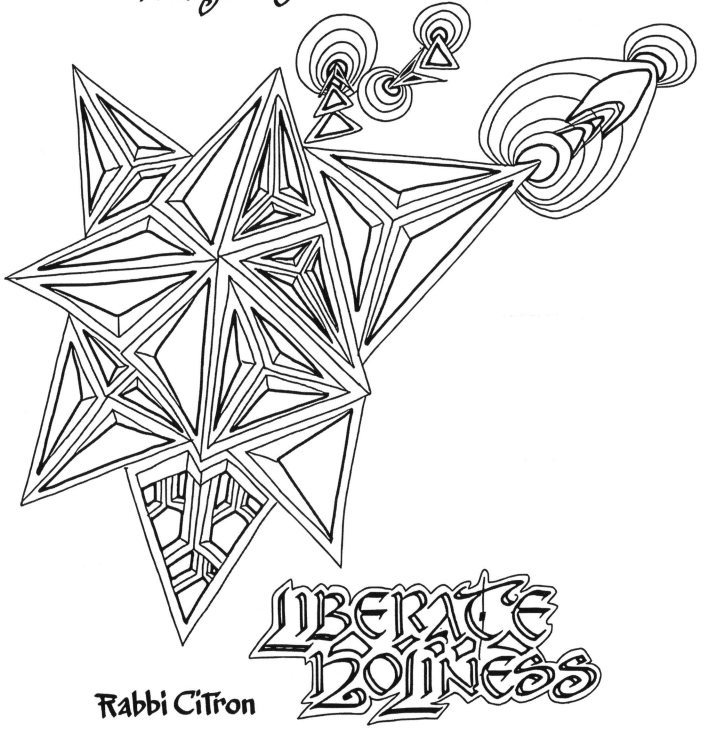

LIBERATE HOLINESS

Rabbi Citron

©1990-2015 Rae Shagalov www.HOLYSPARKS.COM

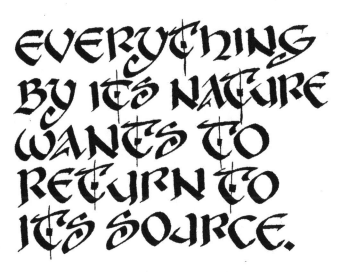

EVERYTHING BY ITS NATURE WANTS TO RETURN TO ITS SOURCE.

THE FLAME OF A CANDLE BY IT'S NATURE FLICKERS UPWARD BECAUSE IT WANTS TO RETURN TO ITS SOURCE. SO IT IS WITH OUR SOULS WHICH FLICKER UPWARD WITH A CRAVING TO RETURN TO OUR HOLY SOURCE.

©1990-2015 Rae Shagalov WWW.HOLYSPARKS.COM

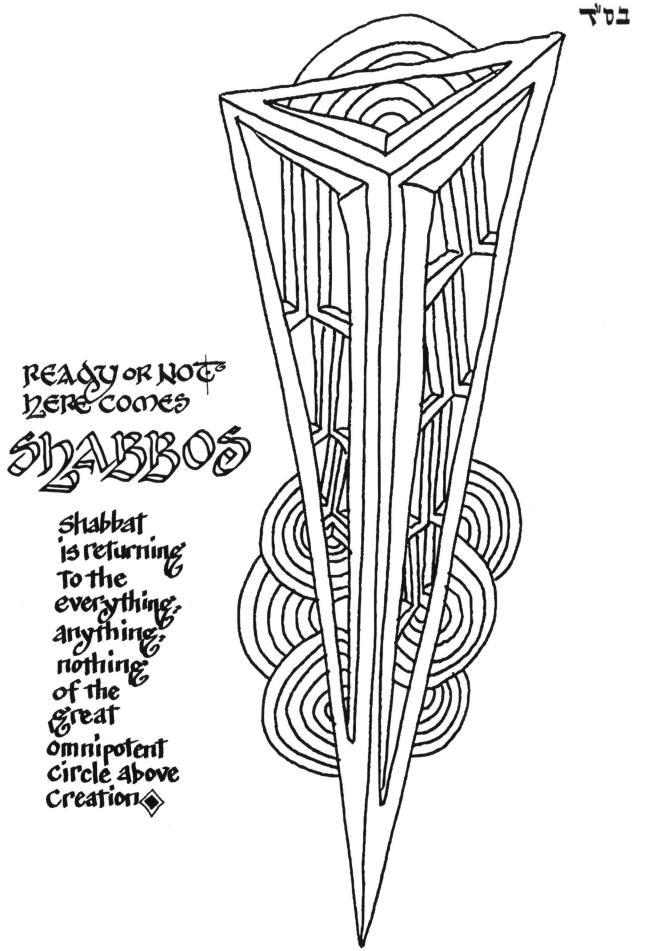

בס"ד

READY OR NOT
HERE COMES

SHABBOS

Shabbat
is returning
to the
everything,
anything,
nothing
of the
great
omnipotent
circle above
Creation◆

Rabbi Manis Friedman Rabbi Yitzchak Ginsburgh

©1990-2015 Rae Shagalov www.HOLYSPARKS.COM

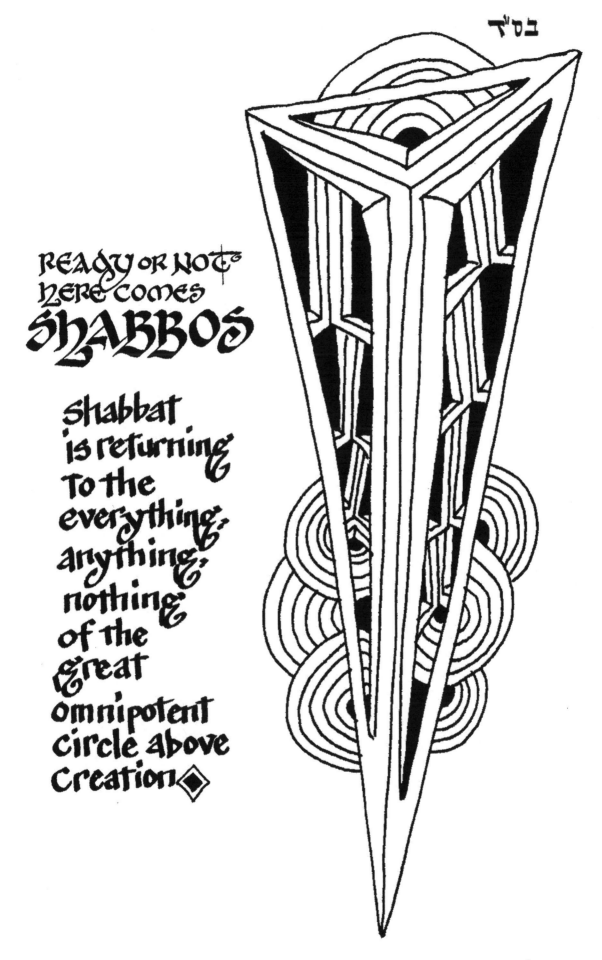

בס״ד

READY OR NOT
HERE COMES
SHABBOS

shabbat
is returning
To the
everything,
anything,
nothing,
of the
great
omnipotent
circle above
creation◆

©1990-2015 Rae Shagalov www.HOLYSPARKS.COM Rabbi Manis Friedman Rabbi Yitzchak Ginsburgh

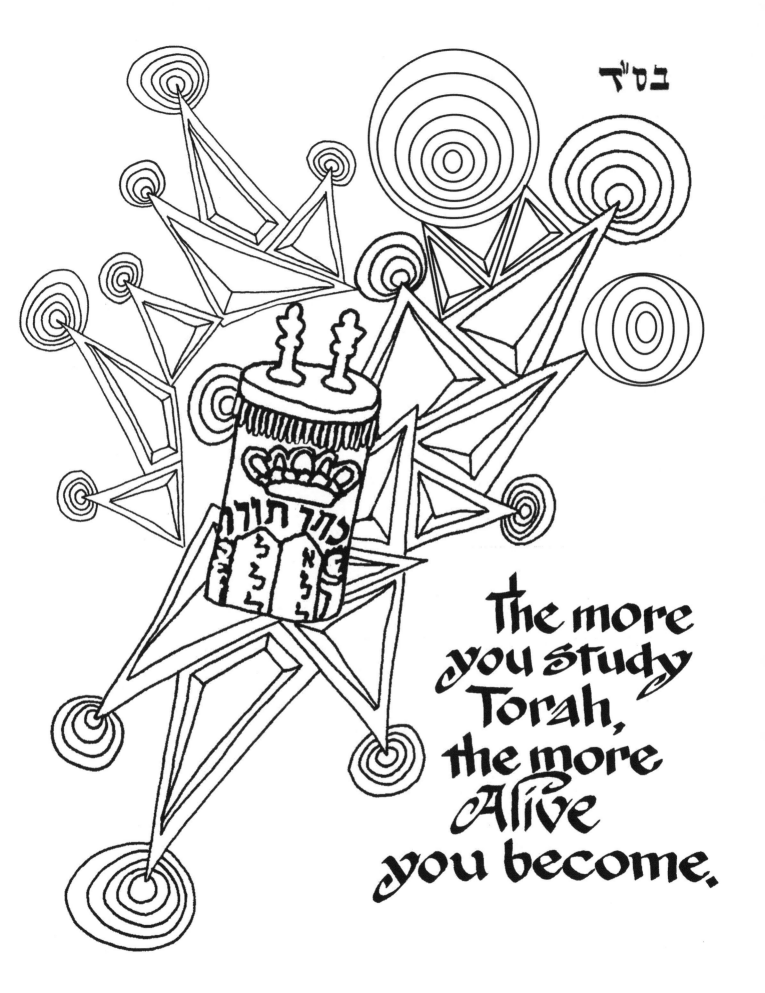

ב"ה

The more
you study
Torah,
the more
Alive
you become.

©1990-2015 Rae Shagalov www.HOLYSPARKS.COM

בס"ד

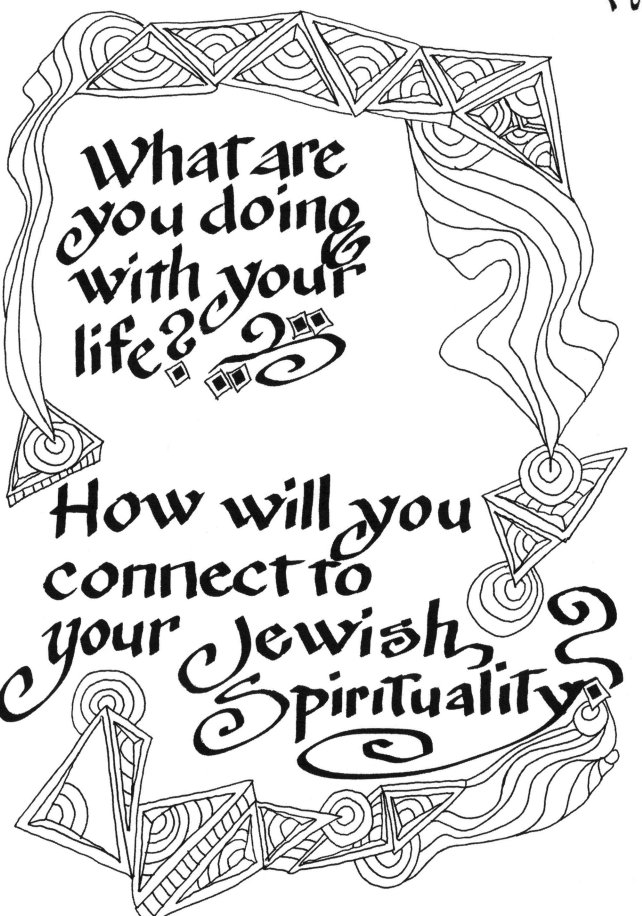

What are you doing with your life?

How will you connect to your Jewish Spirituality?

©1990-2015 Rae Shagalov WWW.HOLYSPARKS.COM

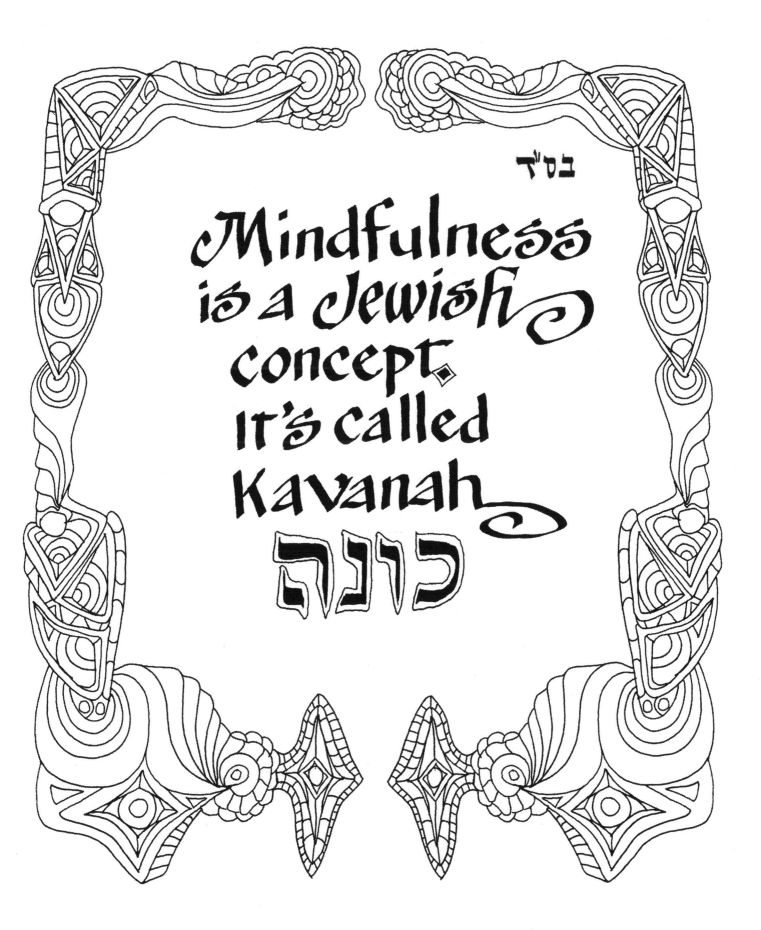

בס"ד

Mindfulness is a Jewish concept. It's called Kavanah כּוּנָה

©1990-2015 Rae Shagalov WWW.HOLYSPARKS.COM

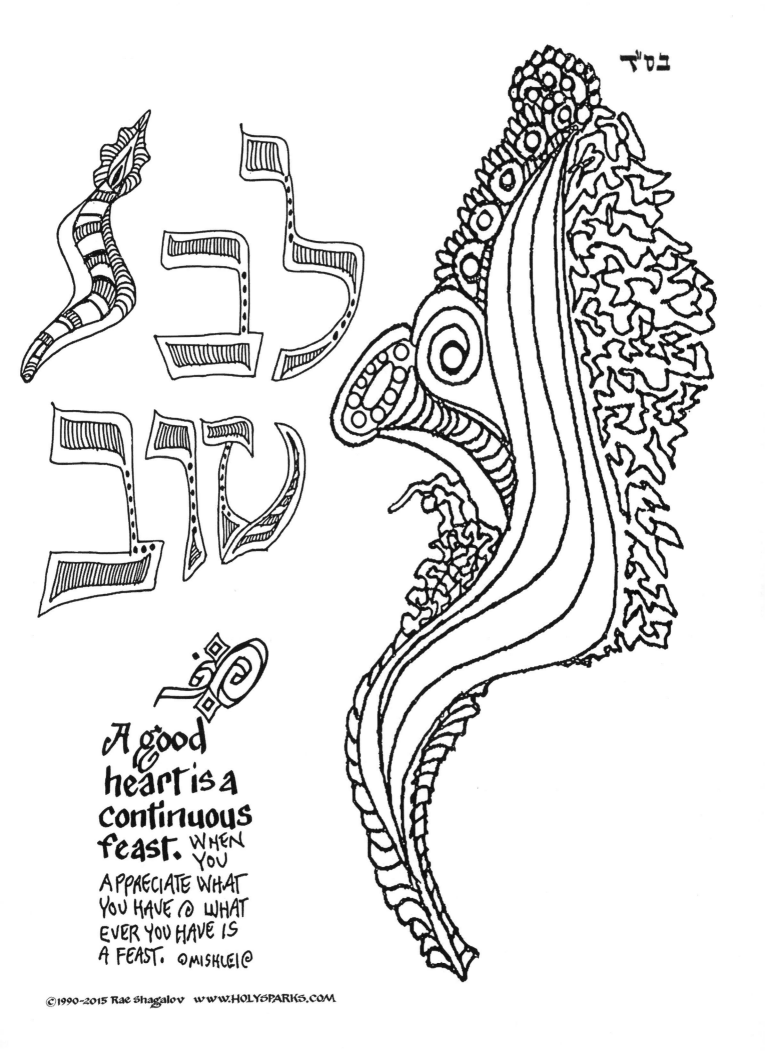

בס"ד

כל
טוב

A good
heart is a
continuous
feast. WHEN
YOU
APPRECIATE WHAT
YOU HAVE @ WHAT
EVER YOU HAVE IS
A FEAST. ◎MISHLEI◎

©1990-2015 Rae Shagalov WWW.HOLYSPARKS.COM

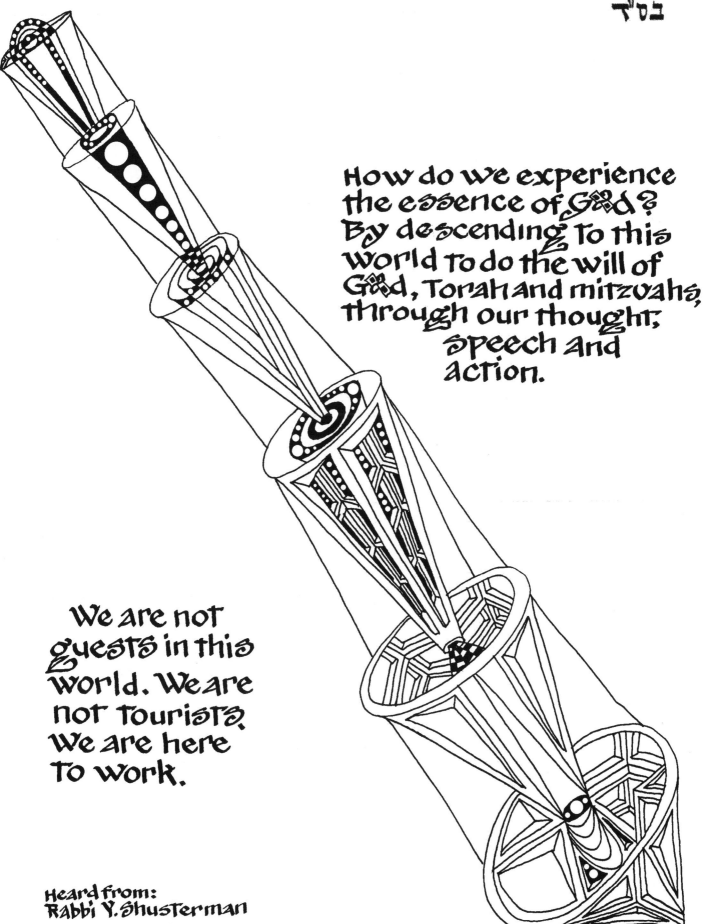

בס"ד

How do we experience the essence of G‑d? By descending to this world to do the will of G‑d, Torah and mitzvahs, through our thought, speech and action.

We are not guests in this world. We are not tourists. We are here to work.

Heard from: Rabbi Y. Shusterman

©1990-2015 Rae Shagalov www.HOLYSPARKS.COM

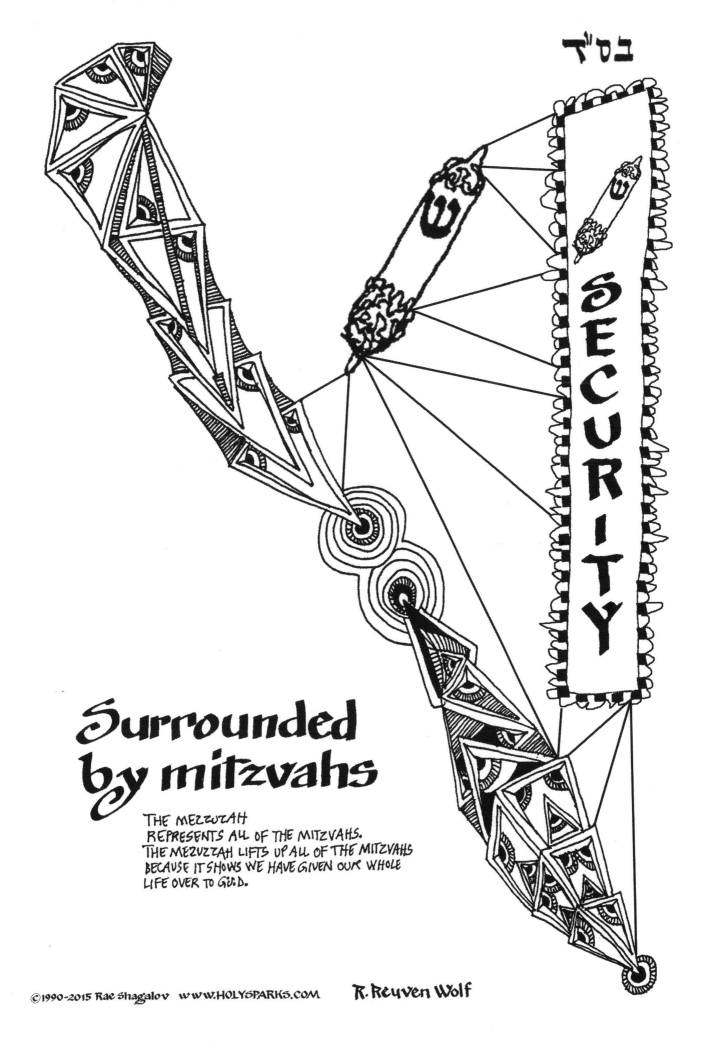

בס״ד

SECURITY

Surrounded by mitzvahs

THE MEZUZAH
REPRESENTS ALL OF THE MITZVAHS.
THE MEZUZZAH LIFTS UP ALL OF THE MITZVAHS
BECAUSE IT SHOWS WE HAVE GIVEN OUR WHOLE
LIFE OVER TO G·D.

©1990-2015 Rae Shagalov www.HOLYSPARKS.COM R. Reuven Wolf

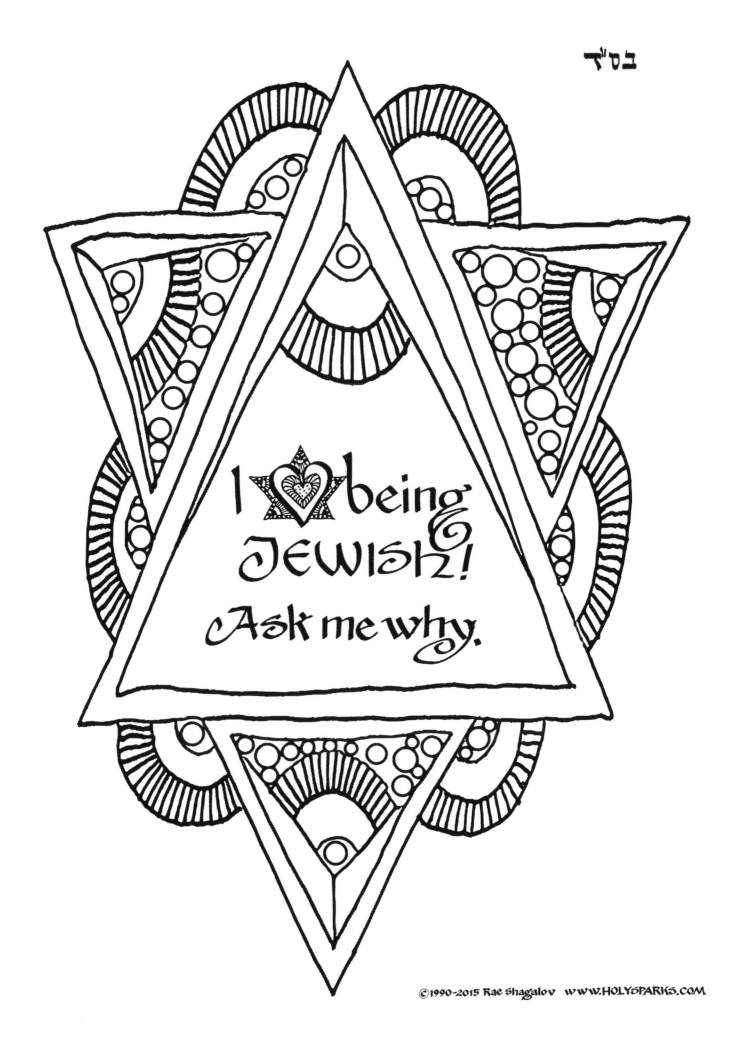

בס"ד

I ♥ being JEWISH! Ask me why.

©1990-2015 Rae Shagalov www.HOLYSPARKS.com

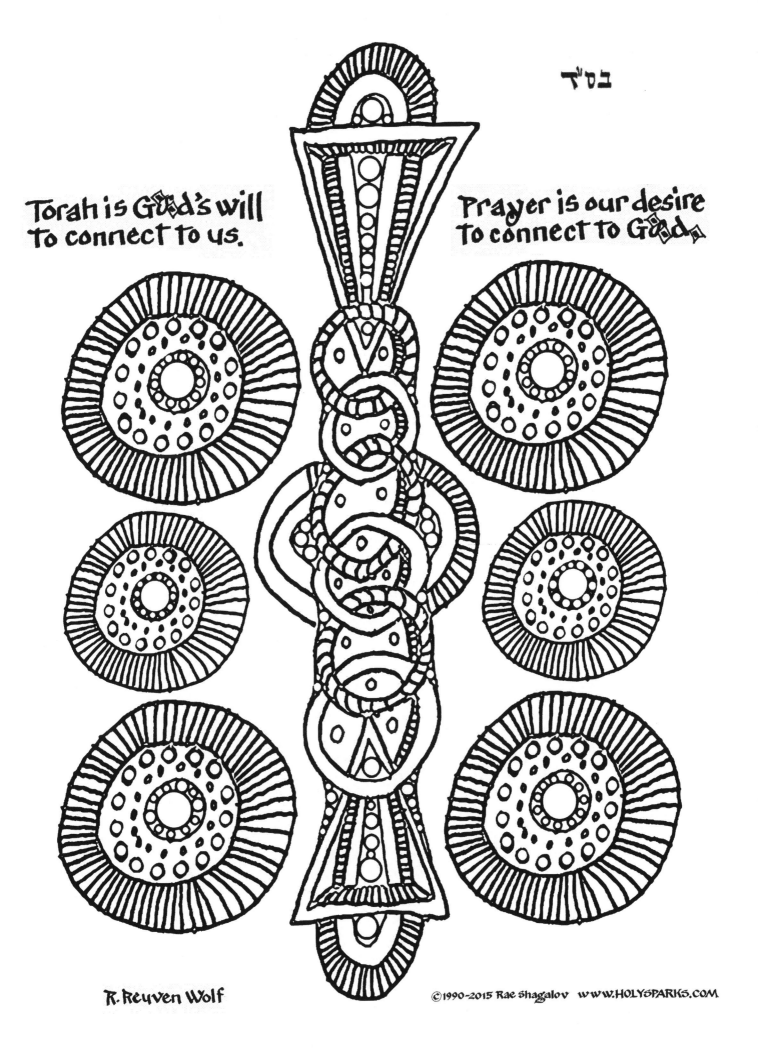

בס"ד

Torah is God's will
To connect to us.

Prayer is our desire
To connect to God.

R. Reuven Wolf

©1990-2015 Rae Shagalov www.HOLYSPARKS.com

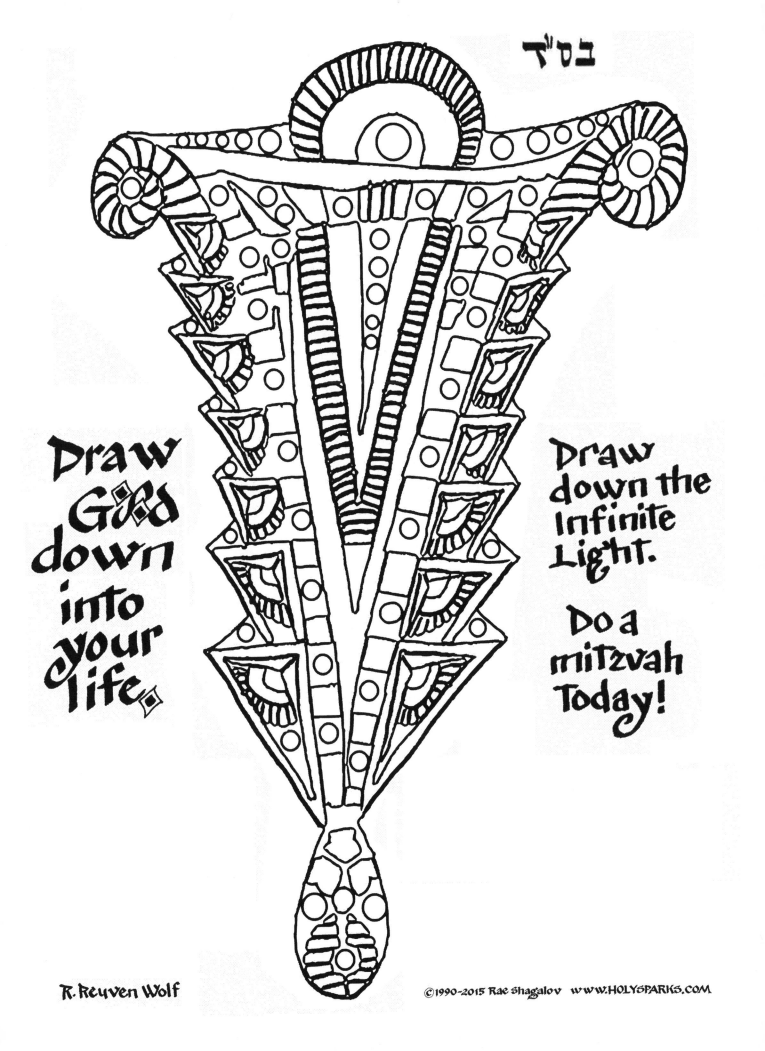

בס"ד

Draw G-d down into your life.

Draw down the Infinite Light.

Do a mitzvah Today!

R. Reuven Wolf

©1990-2015 Rae Shagalov www.HOLYSPARKS.COM

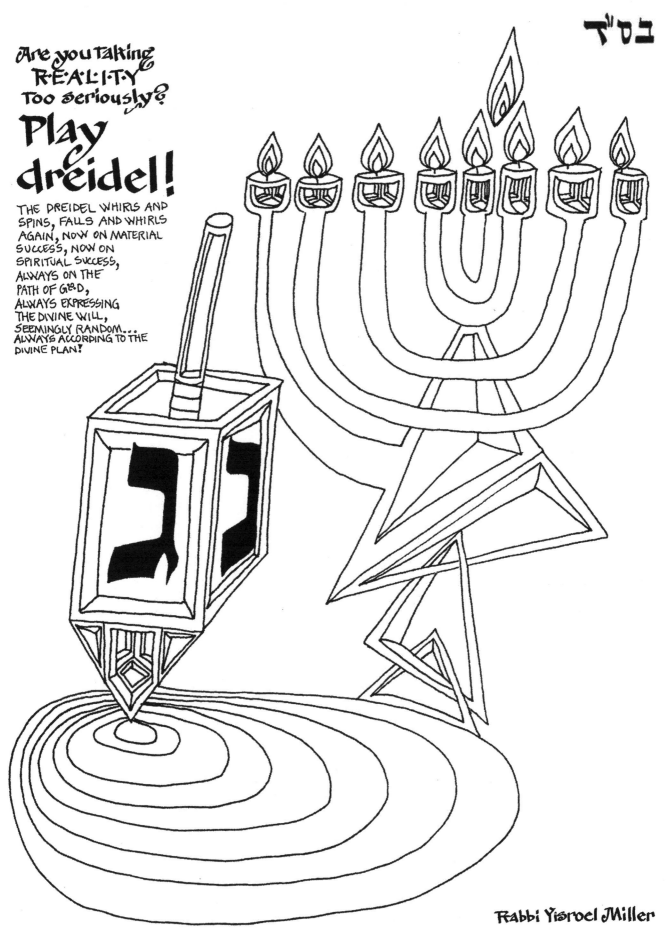

בס"ד

Are you taking R·E·A·L·I·T·Y Too seriously?

Play dreidel!

THE DREIDEL WHIRLS AND SPINS, FALLS AND WHIRLS AGAIN, NOW ON MATERIAL SUCCESS, NOW ON SPIRITUAL SUCCESS, ALWAYS ON THE PATH OF G&D, ALWAYS EXPRESSING THE DIVINE WILL, SEEMINGLY RANDOM... ALWAYS ACCORDING TO THE DIVINE PLAN!

Rabbi Yisroel Miller

©1990-2015 Rae Shagalov www.HOLYSPARKS.COM

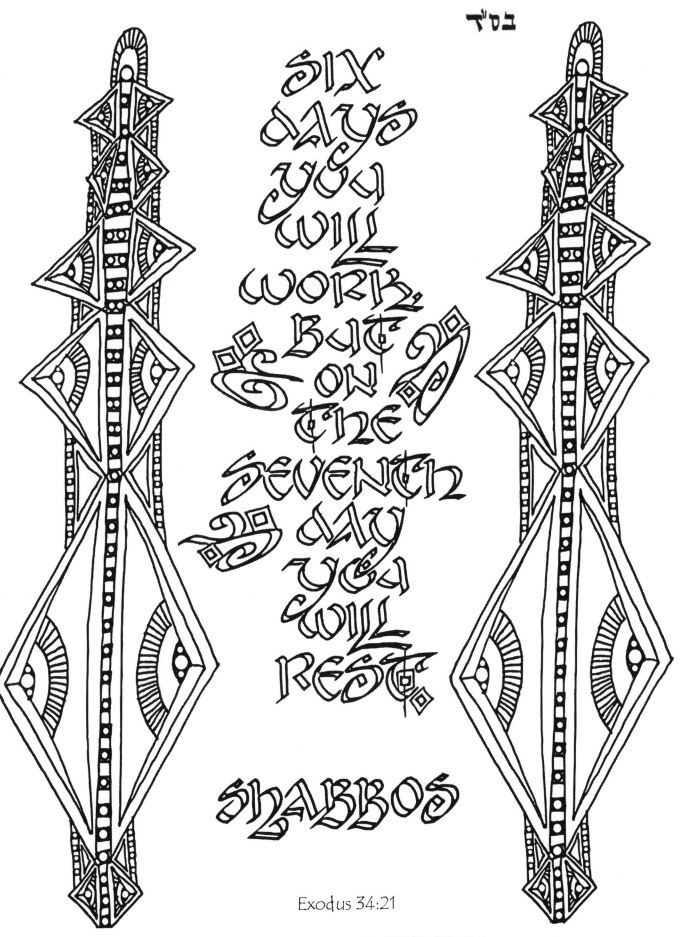

Exodus 34:21

©1990-2015 Rae Shagalov WWW.HOLYSPARKS.COM

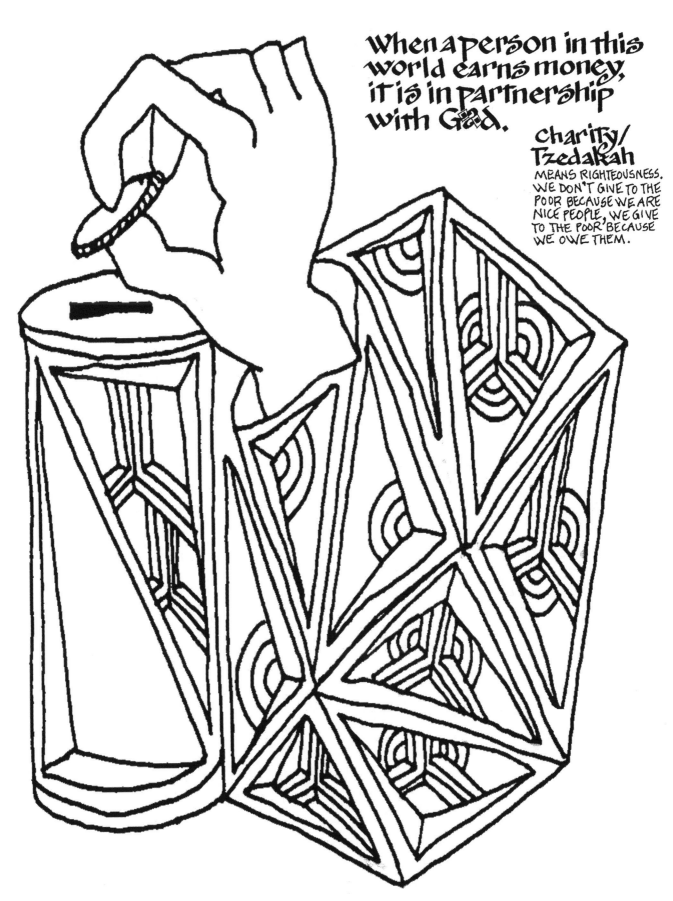

בס"ד

When a person in this world earns money, it is in partnership with God.

Charity/Tzedakah means righteousness. We don't give to the poor because we are nice people, we give to the poor because we owe them.

Rabbi Nachum Sauer ©1990-2015 Rae Shagalov WWW.HOLYSPARKS.COM Rebbetzin Olivia Schwartz

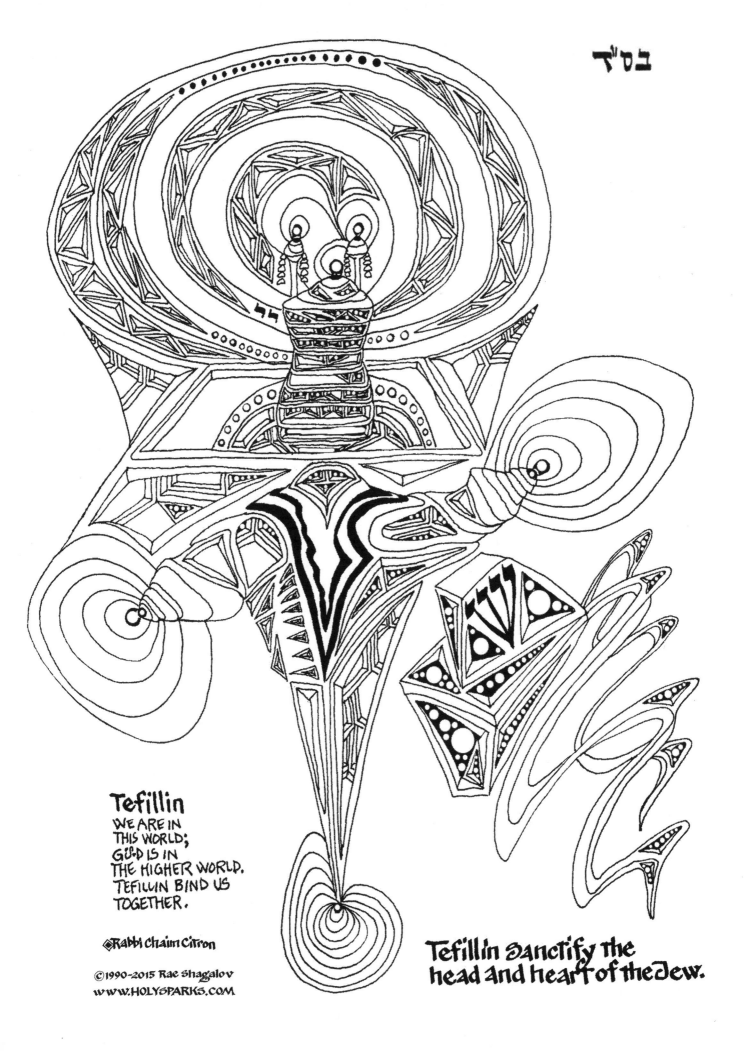

בס"ד

Tefillin
WE ARE IN
THIS WORLD;
G‑D IS IN
THE HIGHER WORLD.
TEFILLIN BIND US
TOGETHER.

©Rabbi Chaim Citron

©1990-2015 Rae Shagalov
WWW.HOLYSPARKS.COM

Tefillin Sanctify the
head and heart of the Jew.

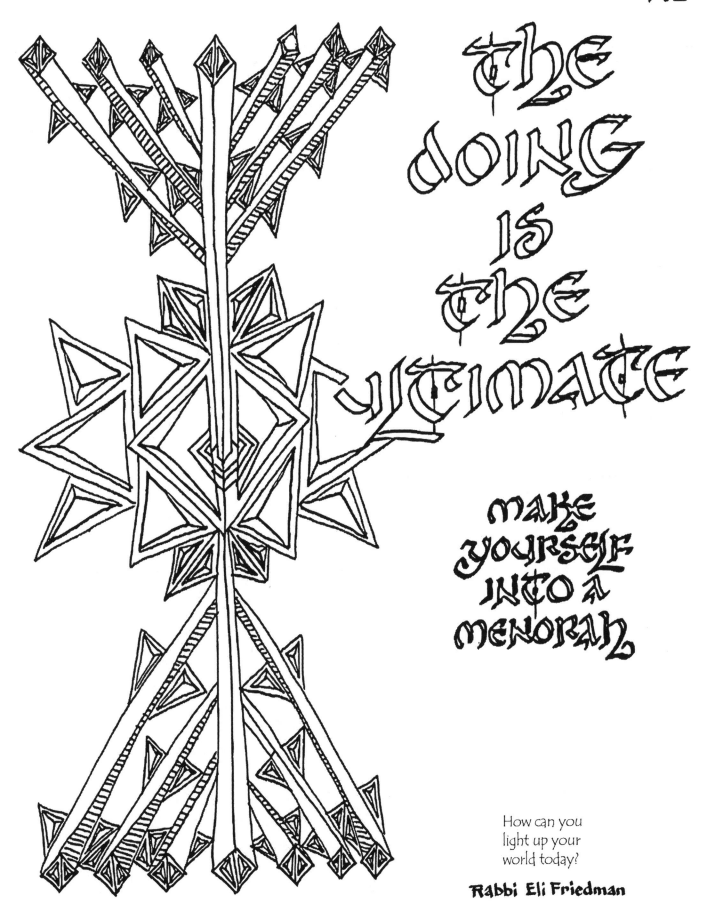

THE
DOING
IS
THE
ULTIMATE

MAKE
YOURSELF
INTO A
MENORAH

How can you
light up your
world today?

Rabbi Eli Friedman

©1990-2015 Rae Shagalov www.HOLYSPARKS.com

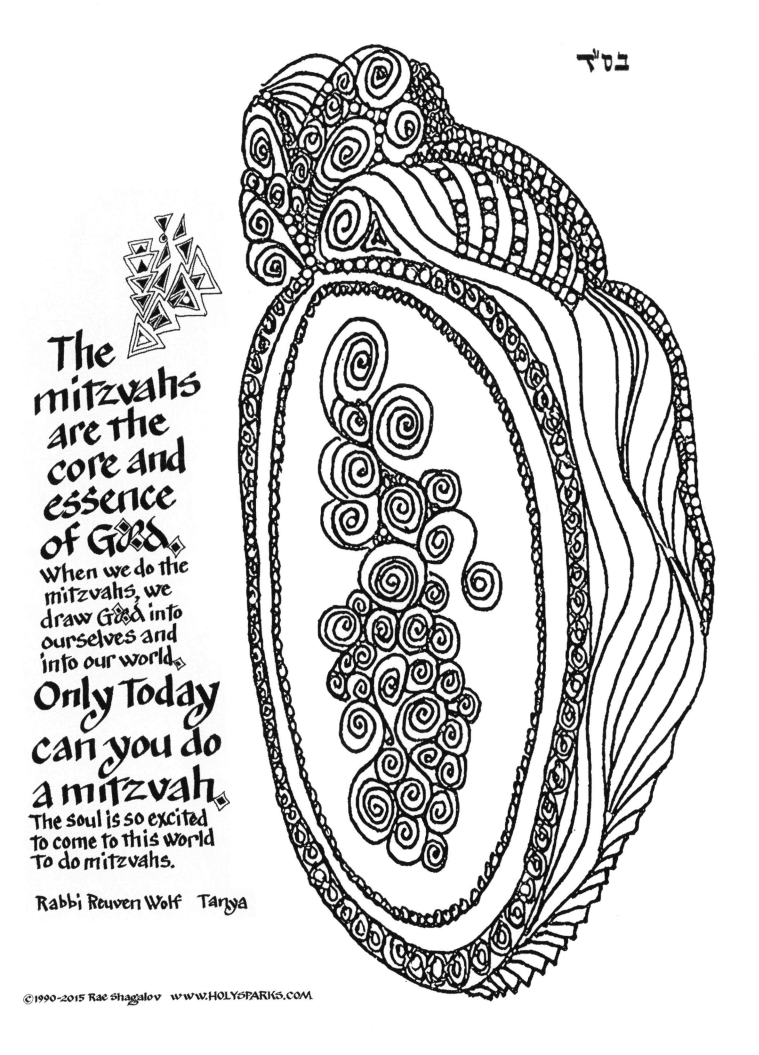

בס"ד

The mitzvahs are the core and essence of G‑d. When we do the mitzvahs, we draw G‑d into ourselves and into our world. Only Today can you do a mitzvah. The soul is so excited to come to this world To do mitzvahs.

Rabbi Reuven Wolf Tanya

©1990-2015 Rae Shagalov WWW.HOLYSPARKS.COM

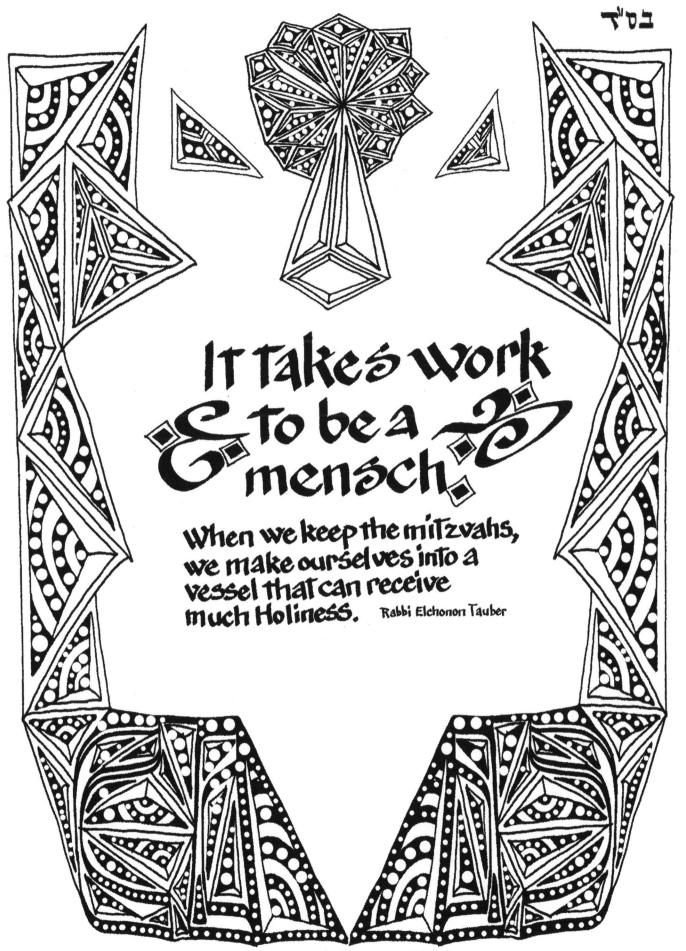

בס"ד

It takes work & to be a mensch.

When we keep the mitzvahs, we make ourselves into a vessel that can receive much Holiness. Rabbi Elchonon Tauber

©1990-2015 Rae Shagalov www.HOLYSPARKS.COM

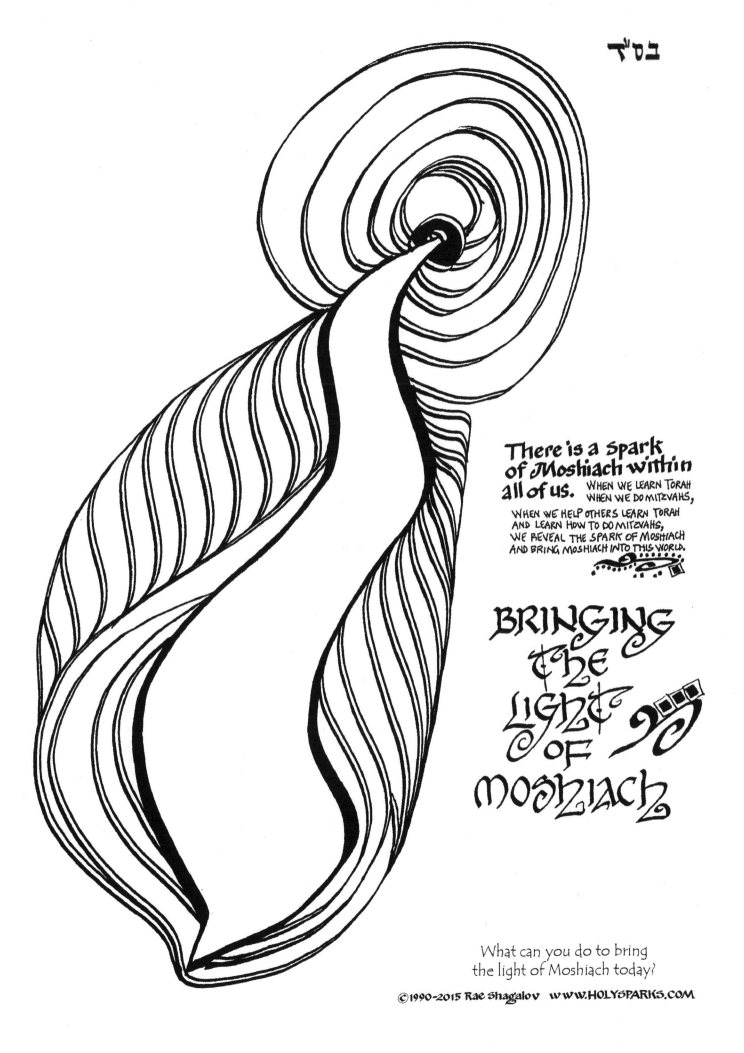

בס"ד

There is a spark of Moshiach within all of us. WHEN WE LEARN TORAH WHEN WE DO MITZVAHS, WHEN WE HELP OTHERS LEARN TORAH AND LEARN HOW TO DO MITZVAHS, WE REVEAL THE SPARK OF MOSHIACH AND BRING MOSHIACH INTO THIS WORLD.

BRINGING THE LIGHT OF MOSHIACH

What can you do to bring the light of Moshiach today?

©1990-2015 Rae Shagalov WWW.HOLYSPARKS.COM

❧ 10 WAYS TO BE JOYFULLY JEWISH ❧

The most important principle in the Torah is the protection of Jewish life. It's more important than Shabbat, more important than holidays, even fasting on Yom Kippur. Right now, in Israel, and everywhere, Jews must stand together in unity and do whatever possible to protect Jewish life.

The Rebbe, Rabbi Menachem M. Schneerson of Lubavitch, teaches that there are ten important *Mitzvahs we can do to protect life. See what you can do:

1) AHAVAS YISROEL: Behave with love towards another Jew.
2) LEARN TORAH: Join a Torah class.
3) Make sure that Jewish children get a TORAH TRUE EDUCATION.
4) Affix kosher MEZUZAS on all doorways of the house.
5) For men and boys over 13: Put on TEFILLIN every weekday.
6) Give CHARITY.
7) Buy JEWISH HOLY BOOKS and learn them.
8) LIGHT SHABBAT & YOM TOV CANDLES. A Mitzvah for women and girls.
9) Eat and drink only KOSHER FOOD.
10) Observe the laws of JEWISH FAMILY PURITY.

In addition the Rebbe urges that:
Every Jewish man, woman and child should have a letter written for them in a **Sefer Torah.

Every person should study either the Rambam's Yad Hachazakah -- Code of Jewish Law -- or the Sefer HaMitzvos.

Concerning Moshiach, the Rebbe stated, "The time for our redemption has arrived!" Everyone should prepare themselves for Moshiach's coming by doing random acts of goodness and kindness, and by studying about what the future redemption will be like. May we merit to see the fulfillment of the Rebbe's prophecy, Now!

*Mitzvahs are Divine Commandments, channels of G-dly light that connect us to G-d.

**There are several Torah scrolls being written to unite Jewish people and protect Jewish life. Letters for children can be purchased for only $1 via the Internet, at: www.kidstorah.org

Listen to inspiring Chassidic Torah classes while you color at Maayon.com.

For more information about how to be Joyfully Jewish, visit:

Holysparks.com Moshiach.net Chabad.org
Jewishwoman.org Jewishkids.org Maayon.com

Learn about the 7 special mitzvahs for Righteous Gentiles
Holysparks.com/pages/7-mitzvahs-for-non-jews

❧ Connect with Rae Shagalov ☙

Sign up to receive free art, coloring pages and Rae's Soul Tips newsletter! Go to: www.holysparks.com

Let's Connect!
Facebook.com/soultips
Pinterest.com/holysparks
Twitter.com/holysparks
Youtube.com/holysparksbooks
Instagram.com/holysparks

❧ About Holy Sparks ☙

Holy Sparks is dedicated to spreading the light of authentic Jewish spirituality and wisdom. Holy Sparks provides and promotes Jewish knowledge, awareness and practice as it applies to people of all faiths and nationalities, regardless of affiliation or background. Holy Sparks helps spiritual seekers, particularly the Jewish people, and others who are looking for inspiration and encouragement, to discover and fulfill their individual talents and potential for service to G-d and mankind, through increasing in acts of goodness, kindness, and holiness.

❧ About Rae Shagalov ☙

Master calligrapher, Rae Shagalov, is the author of the Amazon bestseller, "The Secret Art of Talking to G-d," and the forthcoming 30 book series, "The Secret Art of Jewish Life." Rae is eager to share the beauty and wisdom of Torah through her 3,000 pages of beautifully designed Artnotes that reveal the special message of this exciting time in Jewish History. Her books provide her readers with very practical, joy-based action steps for infusing authentic Jewish spirituality into their daily lives. Rae is also an innovative educator who develops the talents of children at Emek Hebrew Academy in Los Angeles. You can view Rae's Artnotes, animated videos, and read her art blog at: www.holysparks.com.

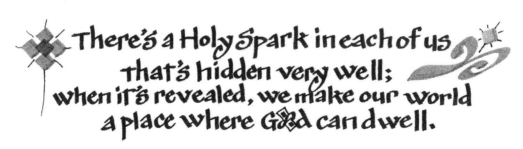

There's a Holy Spark in each of us
that's hidden very well;
when it's revealed, we make our world
a place where G‑d can dwell.

Look for More Interactive Calligraphy Books
By Rae Shagalov on Amazon

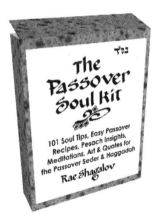

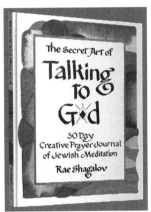

Sign Up for Free Art and Order These
Downloadable Books at www.holysparks.com

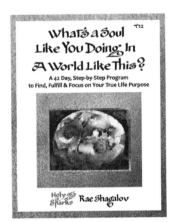

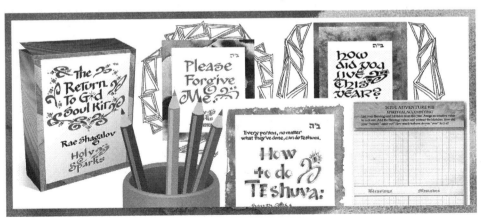

Find and fulfill your purpose in life
in just 6 weeks with the downloadable e-book:
What's a Soul Like You Doing in a World Like This?
Find out more about it here:
http://bit.ly/Soul-Plan

Now, there's a new, creative way to get into
deep introspective Soul Work! Featuring:
28 beautiful calligraphy Artnotes,
21 Soul Adventures - a fun, creative way to do
introspection, and 12 Coloring Pages for the
whole family to discuss how to make good
life changes. Find out more at:
http://bit.ly/return-soul-kit

Made in the USA
Columbia, SC
02 February 2021

32061253R00054